THE LIFE AND WORKS OF
Leonardo
DA VINCI
Linda Doeser

A Compilation of Works from the
BRIDGEMAN ART LIBRARY

SHOOTING STAR PRESS

Shooting Star Press Inc
230 Fifth Avenue, New York, New York 10001

Da Vinci

© Parragon Book Service Ltd 1994

This edition printed for:
Shooting Star Press, Inc.
230 Fifth Avenue - Suite 1212
New York, NY 10001

ISBN 1 56924 173 2

Printed in Italy

Editor: Alexa Stace
Designer: Robert Mathias

The publishers would like to thank Joanna Hartley at the Bridgeman Art Library for her invaluable help

LEONARDO DA VINCI 1452-1519

BY ANY STANDARDS, Leonardo da Vinci was an extraordinary man. He epitomized the Renaissance ideal of the polymath – artist, raconteur, musician, scientist, mathematician and engineer – a man of many talents with an insatiable curiosity and thirst for knowledge.

He was born at Anchiano, a village near the little town of Vinci, on 15 April, 1452. His father was to become a successful notary while his mother, Caterina, was a peasant with whom his father conducted a somewhat irregular liaison. The young Leonardo thrived in the countryside, where he developed an enduring love of nature. As a boy, he was asked to design a shield for one of his father's connections. He is said to have produced an extraordinary bestiary, based on first-hand observation of lizards, crickets, snakes, butterflies, grasshoppers and bats. From all reports, this was the first occasion when he revealed his fascination with mobile, twisting, living forms. He is also recorded as having a great love and skilful mastery of horses. They featured so prominently in many of his mature works that this seems very likely.

Some time before 1469, Leonardo went with his father to live in Florence and in 1472, he was inscribed on the roll of the guild of St Luke – the guild of painters. His master was Andrea Verrocchio, and records show that he was still employed in Verrocchio's workshop in the Via dell'Agnolo in 1476.

Verrocchio's influence on the younger man is difficult to assess. Certainly, the master's use of curved and curling forms found an echo in his pupil. Verrocchio's paintings have a certain grandeur but do not really stir the imagination, whereas his sculptures have a greater force and seem to have been a stronger influence on Leonardo.

There is no firm evidence of when Leonardo went to Milan, but his first documented commission there dates from 1483. His reasons for going are not clear; but he may have been attracted by the stimulating atmosphere of the Sforza court, with its many doctors, scientists, military engineers and mathematicians. There were other reasons for leaving Florence: high taxation meant that some patrons never paid for the work they commissioned, professional competition was extremely fierce, war and plague presented acute physical dangers.

Leonardo became established at Duke Lodovico's court, where besides painting, his patron called on his services for a diversity of tasks – to supervise pageants and instal 'central heating', for example. This kind of role must have appealed immensely both to Leonardo's character and his intellect. In fact, in a letter, he describes himself as an engineer and makes only a passing reference to his painting. During this period he also painted portraits, carried out one major commission, *The Last Supper*, and completed much of the preparatory work on the Sforza monument, although this was never cast.

On 2 October, 1498, Leonardo was given a property outside the Porta Vercellina of Milan and appointed *ingenere camerale*. A French invasion was expected and he was very busy planning the city's defences, although two other major works date from this period. He also collaborated with the mathematician Luca Pacioli on *Divina Proportione*, the two men having been close friends since Pacioli's arrival in Milan in 1496.

The French successfully entered Milan in 1499 and Lodovico was taken prisoner and sent to France. Leonardo, together with Luca Pacioli, left Milan after 18 years with the Sforzas. He probably went directly to Mantua, where he drew a portrait of Isabella d'Este. By 24 April, 1500, he had returned to Florence and found a very different city from the one he had left almost 20 years earlier, with a wave of revivalism in religion and republicanism in politics. Leonardo achieved almost immediate public acclaim, following the exhibition of his cartoon of the Virgin and St Anne planned as an altarpiece. Michelangelo's reputation in Florence was already well established by this time. These two giants

never liked each other and Leonardo made no secret of the fact that he considered sculpture inferior to painting, but Michelangelo's fame was an irritant.

Once again, Leonardo became an engineer; draining marshes, drawing maps and designing a canal system. He met Niccolò Machiavelli in Urbino and this encounter was to lead to a close association and his most important commission. Meanwhile, he produced some magnificent red chalk drawings of Cesare Borgia.

In 1503, he embarked on his three most prolific years as a painter. His most famous portrait, the *Mona Lisa,* with her renowned enigmatic smile, may have been painted at this time. Much of Leonardo's work in Florence between 1503 and 1507 has been lost, including *Leda.* He found the mechanics of painting tedious and preferred to concentrate his imaginative skills on drawing and planning his compositions.

As a result of his flourishing association with Machiavelli, Leonardo was commissioned to paint a fresco in the Sala del Gran Consiglio of the Palazzo Vecchio. He began work on the cartoon for the fresco – the *Battle of Anghiari* – in October 1503, but progress seems to have been slow. Leonardo completed his cartoon by the end of 1504 and began painting, using an unusual, possibly encaustic technique. This dried erratically and was generally unsuccessful. The fresco was never finished but later, a special frame was made to enclose the completed part and it was regarded by some as one of the best things to see when visiting Florence. It was eventually overpainted by Vasari.

Throughout 1507, Leonardo was working for the King of France, although his immediate patron was Charles d'Amboise, Lord of Chaumant and Governor of Milan. In many ways, d'Amboise reinstated the glories of the Sforza court. Leonardo was in his element, working as a painter, engineer and general artistic advisor. D'Amboise died in 1511, but Leonardo remained in Milan until 24 September, 1513. Then he left for Rome, drawn, as were many, by Giovanni de' Medici who had recently become Pope Leo X.

Leonardo was installed in rooms in the Belvedere of the Vatican but the bustle caused by the country's leading artists and their entourages all

living together was not to his taste. Michelangelo's unassailable position in Rome as a result of his work on the Sistine Chapel was also unpalatable. Perhaps Leonardo's obsessive fascination with the power of water and his many sketches for the *Deluge* reflect a turbulence of mind and spirit.

Leonardo's last surviving picture is almost certainly *St John* and it was probably painted in 1514-15. In March 1516 he accepted an invitation from François I to live in France and was given a manor near Cloux. On 10 October, 1517, Leonardo was visited by Cardinal Louis of Aragon whose secretary wrote an account of the meeting. He mentions three paintings, two identifiable as *The Virgin and Child and St Anne* and *St John* and the third a portrait of a Florentine lady. He also states that Leonardo was suffering from some kind of paralysis of the right hand. Leonardo was left-handed, but this observation may, in fact, refer to his 'working' hand, meaning his left. It is obvious from manuscripts that this paralysis did not prevent Leonardo using his fingers, as his writing was as clear and firm as always. Some of his drawings, however, have a lack of firmness and clarity that suggest that the problem may have affected the movement of his arm.

On 2 May, 1519, Leonardo died at Cloux. He left his drawings and manuscripts to his loyal friend Francesco Melzi. Melzi guarded the work jealously throughout his lifetime but, foolishly, made no provision in his will for its continued care. His son, Orazio, who had absolutely no interest in art or science, allowed this priceless collection to be broken up, lost, stolen and vandalized in a manner that can only be described as criminal.

NOTE: It is often very difficult to define the medium used in Leonardo's works. He was extremely experimental, and often tried out new recipes, or mixed paints from recipes found in classical sources: the exact ingredients are often obscure or completely unknown. Also much of Leonardo's work has been 'restored' at different times in the last 400 years. Often heavy-handed and with little respect for the original, these restorers paid scant regard to the medium originally used. Some paintings on wooden panels have been transferred to canvas.

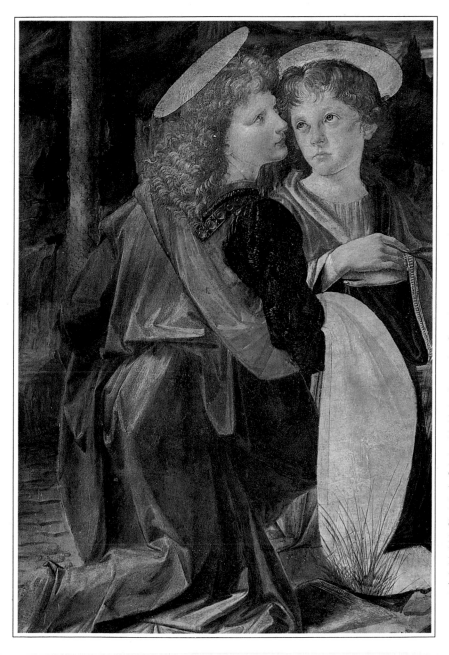

◁ **Baptism of Christ (Verrocchio) detail** c 1472

IT IS NOT UNLIKELY that part of the work produced by Verrocchio's studio in the early 1470s and sold as Verrocchio's was painted by his talented assistant. Not only was this a fairly common practice, there is documentary evidence of Leonardo's responsibility for painting an angel in the *Baptism*. Certainly, there is a striking contrast between the two angels. One has the sureness of touch that comes with maturity, yet remains just another example of the many painted angels of the period. The other is the work of a younger, less sure hand, but has a quality of other-worldliness not, perhaps, previously seen in Renaissance painting. It was about this time that Verrocchio abandoned painting in order to concentrate on sculpture and working with gold. Vasari, Leonardo's biographer, attributes this decision to the master's recognition that his knowledge and use of colour had been surpassed by the younger artist.

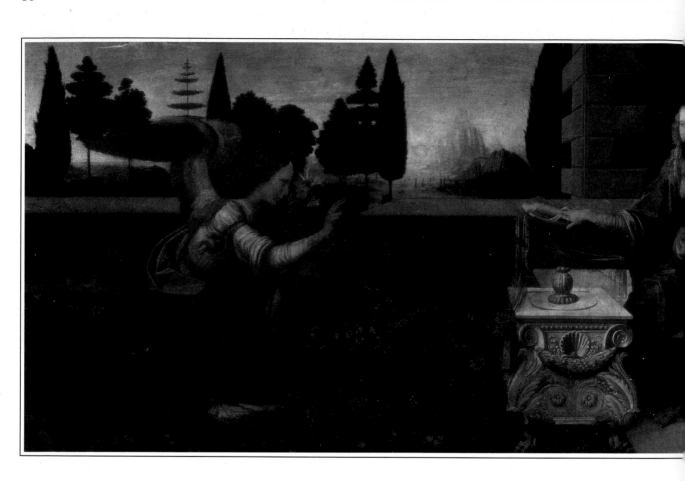

◁ **The Annunciation** c 1472-3

IT IS LIKELY THAT this large 'set piece' followed soon after the angel in Verrocchio's *Baptism of Christ*. It lacks the mastery of technique and composition which we associate with the mature Leonardo, but there are aspects of the work which act as signposts to the artist he was to become. Some authorities have been unwilling to recognize this as Leonardo's work at all. The composition lacks both dynamism and drama. While the architectural details and perspective have been drawn with draughtsman-like care, they seem to have no proper spatial or metaphysical relationship with the figures of the angel and the Virgin. There is an uncharacteristic discordance in the use of colour, and an overall artificiality. All this has the hallmark of the work of a young and inexperienced artist. However, Leonardo's observation and love of nature are already apparent in the distant landscape and in the swirling flowers growing in the foreground. The evening light against which the trees stand in silhouette was already fascinating the young painter.

There is a striking similarity between folded draperies in this work and those of the angel in the *Baptism*.

The Annunciation (detail) c 1472-3

THE ANGEL'S WINGS were extended to be in keeping with the Church's rules on the nature of angels. Originally, Leonardo based them on his observation of birds' wings. They fitted closely onto the angel's shoulders, where they seemed to grow as naturally as those of a bird. Ecclesiastical correctness has resulted in crude and smeary overpainting.

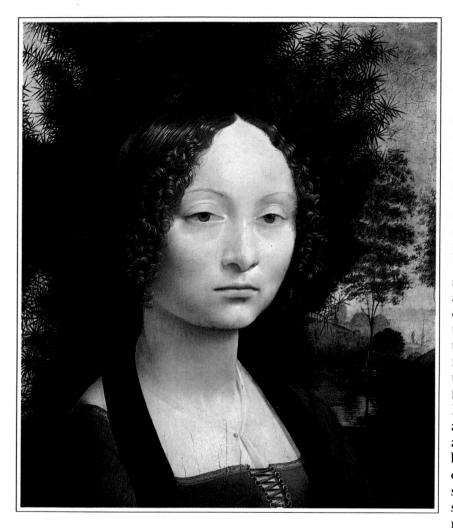

◁ **Ginevra De' Benci** 1474

PORTRAITS OF FLORENTINE ladies were usually commissioned in celebration of their marriages. We can only speculate why such a lovely creature contemplated the prospect with this haunting air of sadness. The picture appears to have been cut off at the bottom and it is likely that the original portrait included the lady's hands. Nevertheless, it is the best preserved of Leonardo's early paintings and shows the delicacy of touch and deep humanity that characterized his work during this period. The perfect oval of the face with its finely modelled features is the only unbroken area of light and the full focus of attention. Elsewhere in the portrait there are strong contrasts of light and shade, and light areas are broken up by the spiky leaves of the juniper bush behind the sitter's head. The juniper is significant as a play on the name Ginevra.

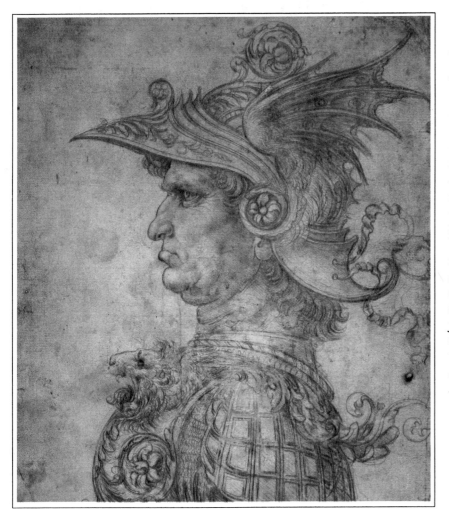

◁ **Head of a Warrior** c 1475

Silverpoint drawing

THE ANTIQUE WARRIOR is one Leonardo's most finished early drawings. At this time he was still working in Verrocchio's studio, and the powerful influence of sculptural form is apparent. If Leonardo's natural instincts lay in the depiction of moving, twisting forms, it was through Verrocchio's guidance and influence that they found expression. Reliefs and sculptures by Verrocchio are in a direct line with this drawing, just as the warrior's mature and virile face is in a direct line with the Apostles of *The Last Supper* and warriors of the *Battle of Anghiari*.

▷ **Madonna Benois** c 1478-80

IT IS INTERESTING to compare the finished painting with Leonardo's studies for this work. In many ways, the painting lacks the spontaneity, vitality and lightness of touch that his studies capture so delightfully. Whether this is because Leonardo was restricted by the conventions prevailing in contemporary Florence or because, as later proved to be the case, he lost interest in the process of painting is debatable. Some of the hallmarks of Leonardo's later style are already apparent in this early work: the simplicity and lack of superfluous ornament and the naturalness of the composition, for example. However, the baby seems awkward and disproportionate and there is a lack of vitality, although this may be due, at least in part, to the condition of the painting.

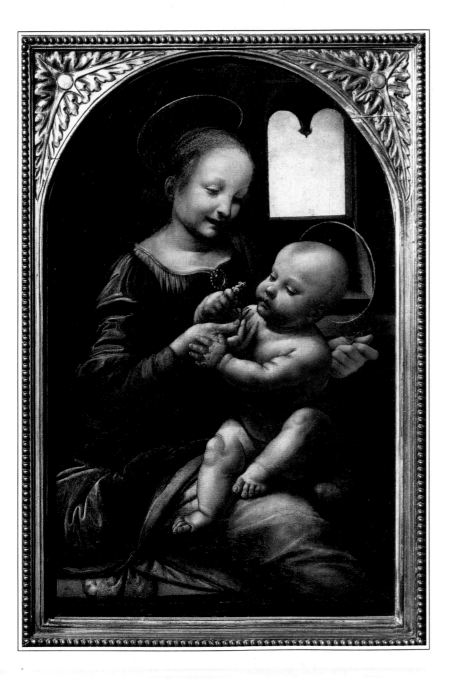

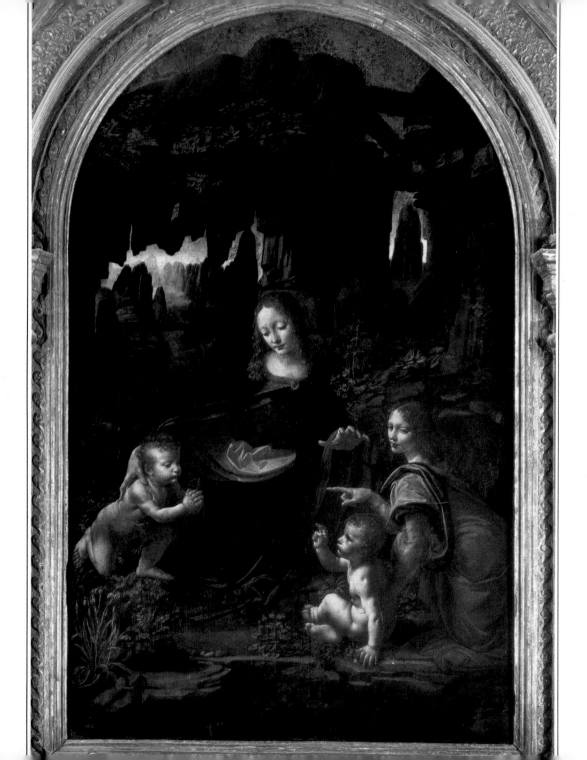

◁ **The Virgin of the Rocks**
c 1478

Oil on canvas

CONSIDERED BY MANY to be the great masterpiece of Leonardo's early career, this painting has been the cause of much speculation. For some time it was thought to be the picture commissioned by the Confraternity of the Immaculate Conception in April 1483. It now seems more likely that the *Virgin of the Rocks* exhibited in London's National Gallery is the painting commissioned in 1483. This version, now in the Louvre Museum in Paris, is painted in what is unmistakably Leonardo's early style, and it is likely that he completed it while still in Florence. This painting has an extraordinary freshness and beauty, even though it conforms to many of the conventions of the time. The dimpled skin of the infant Christ's arm, the finely drawn hands, the perfect beauty of the angel's face, the sweetness of the Virgin's expression are a magical blending of the natural and the ideal. The imagery of the painting has provoked much thought. The

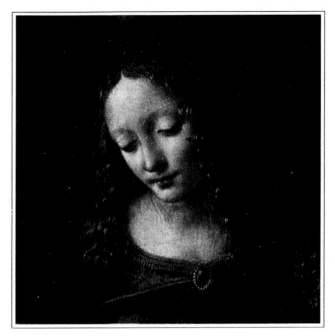

two hands directly above the infant Christ's head serve to isolate him within the painting. He blesses St. John, who represents the human race. He, in turn, kneels in worship and is shielded by the Virgin's cloak and embracing arm. The angel looks out of the painting – but we do not know at what or whom – and, most confusingly of all, points at St John in a most distracting manner. Why Leonardo draws the eye so strongly towards St John remains a mystery.

△ **The Virgin of the Rocks**
(detail) c 1478

Oil on canvas

THE PICTURE was originally painted on a panel and later transferred to canvas. It is much obscured by many layers of discoloured varnish and the composition of some of the pigments has caused the surface to crack. It is, therefore, difficult for the modern eye to appreciate the luminosity and subtle colour for which Leonardo was known.

▷ **The Litta Madonna** c 1480

MODERN RESTORATION techniques have resulted in something closer to Leonardo's original work. This painting was a prime example of the problems faced by art historians and art-lovers when looking at the works of Leonardo. As was often the case, Leonardo never finished the painting and it was completed by another artist in 1495. In the 19th century, it was transferred from its original panel to canvas and the technique involved almost total overpainting. The composition, the Madonna's pose, the angle of the Christ Child's body, the landscape perceived through the windows and, most of all, the modelling of the Madonna's head all have the authentic touch. The hand responsible for the depiction of the landscapes, the folds of the Madonna's robe and, particularly, the head of Christ, was another's.

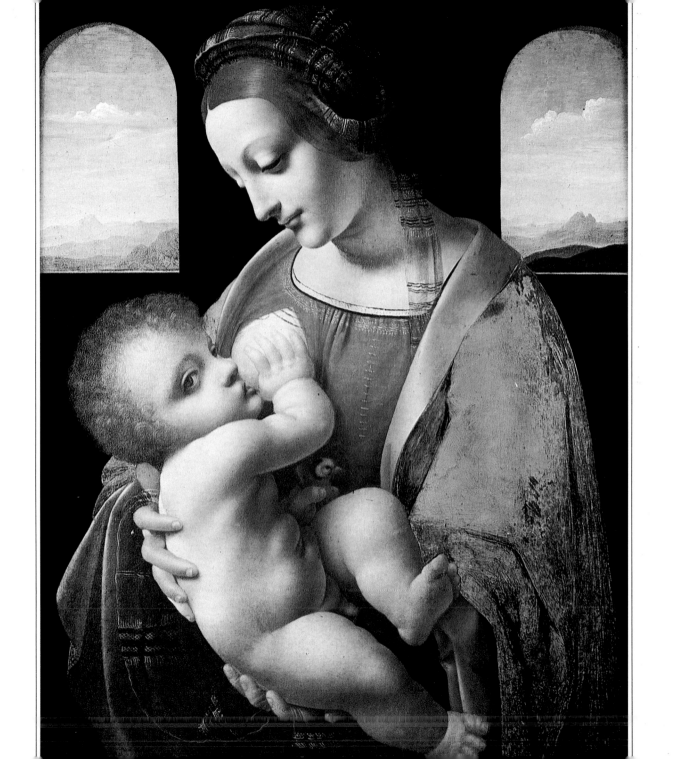

▷ **Horse and Rider** 1481

Silverpoint drawing

THIS IS ONE OF a number of magical silverpoint studies of horses on which Leonardo worked when preparing the altarpiece *Adoration of the Magi*. The delicacy of line and the medium have an almost ethereal quality, which does not in any way undermine our sense of the animal's muscular strength and powerful solidity. Leonardo's combined intellectual understanding and first-hand observation of nature are abundantly demonstrated in this delightful study.

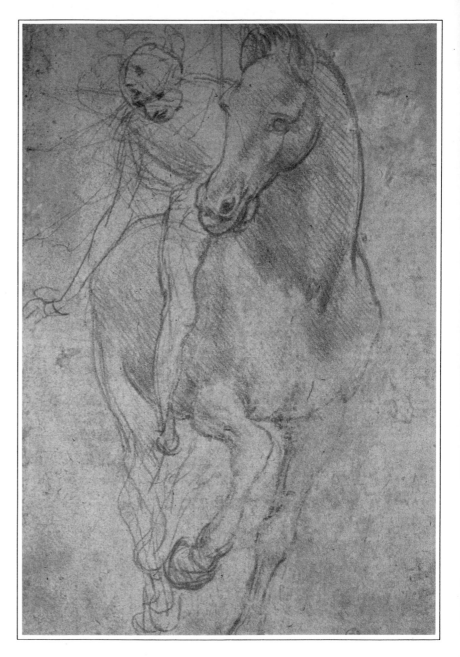

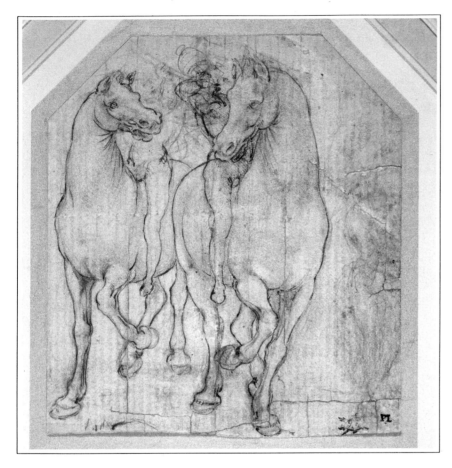

◁ **Study for the Adoration of the Magi** 1481

Metalpoint drawing

THE HORSES in the background of Leonardo's mysterious and visionary painting, *Adoration of the Magi* are only one aspect of many that has exercised the minds of art historians for centuries. Some have a down-to-earth, no-nonsense, natural quality to them, while others are strange and dream-like, their bodies twisted into agitated shapes. This metalpoint drawing is a study somewhere between these two extremes. The animals have a quality of solid reality, but there is an underlying current of the frantic and confusing.

▷ **Adoration of the Magi** 1481-2

ONE OF LEONARDO'S most ambitious compositions, this was never completed. It is virtually impossible to count the number of figures, as the closer one looks, the more they melt and blend together, giving the painting a dream-like quality that is wholly appropriate to Leonardo's allegorical vision. It is, perhaps, enough to say that there are more than 60 figures and some 10 or more animals. The central figures of the Virgin and Christ, the Magi and St Joseph are clearly depicted (even though the actual painting of the Virgin was never finished). The other figures are more mysterious and difficult to define. The eye is drawn to the two upright figures in the foreground: the philosophic man, sunk deep in meditation, to the left, counterbalanced by the young man in armour to the right. There is a tradition that this figure, gazing away from the scene with such lack of interest, is a portrait of Leonardo himself. Themes and motifs that would recur time and again are apparent in this intriguing work: an old man whose haggard face is reminiscent of *St Jerome* (1483); St Joseph's stubborn down-to-earth expression bears a striking resemblance to St Andrew in *The Last Supper* (1497); the upward pointing hand of an angel will reappear again and again, and the mounted figures in the background are the direct ancestors of the horsemen in *Battle of Anghiari* (1504).

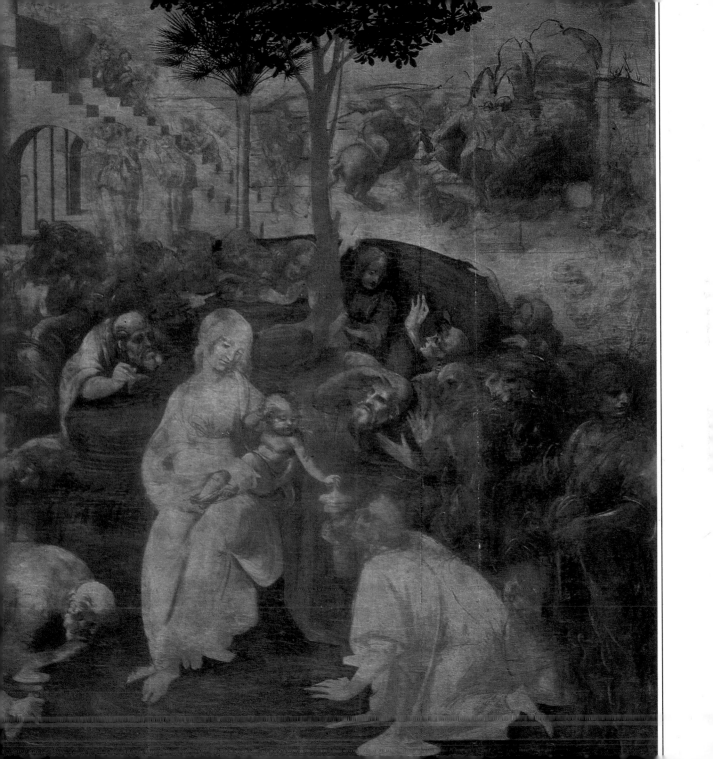

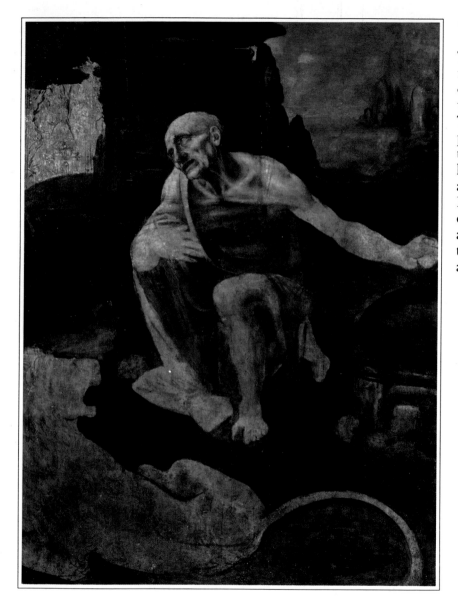

◁ **St Jerome** c 1483

THIS UNFINISHED work still reveals some of the essential characteristics of Leonardo's work in his early days at Milan. The drama of the old man's pose with outflung right arm, the dark cave entrance and the landscape in the background all have the authentic touch. However, the work was badly damaged, part of it having apparently been used as a table before it was rescued and, to some extent, restored.

▷ **The Lady with the Ermine**
c 1483-8

THIS IS THOUGHT to be a portrait of Cecilia Gallerani who became Duke Lodovico's mistress in 1481, and was probably painted shortly afterwards. The ermine was one of Lodovico's emblems, and there is also a possible play on the lady's name and the Greek word for ermine. Cecilia Gallerani wrote of her portrait by Leonardo to Isabella d'Este, so evidence of its authenticity is strong. Parts of the picture have been damaged and there are signs of repainting. However, the modelling of the lady's face, particularly the eyes and nose, has the unmistakable masterly touch of Leonardo. The ermine is surely pure Leonardo – a living, breathing, muscular, silky, lively creature that only a consummate artist with a passionate love and knowledge of nature could depict.

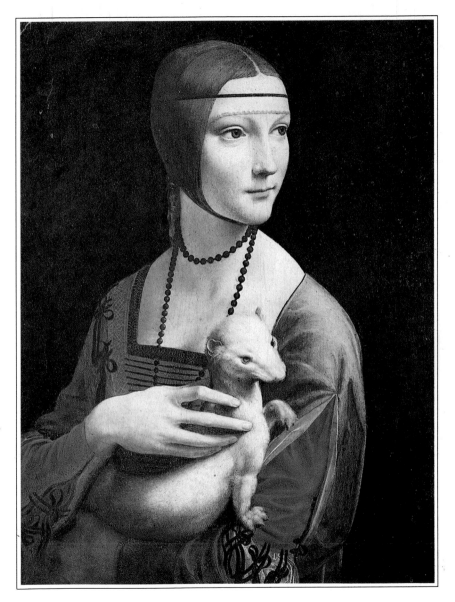

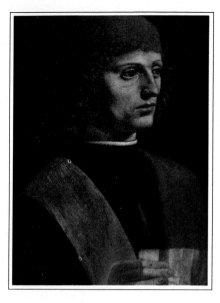

◁ **Portrait of a Musician** c 1485

See detail opposite

PROBABLY THE BEST preserved of all Leonardo's paintings, this portrait is, ironically, one of the least important. Leonardo's close observation of the natural world is powerfully apparent in this work, especially in the subtle rendering of the light and shadows on the unknown musician's face. The Sforza court in Milan, with its abundance of engineers, doctors and scientists, was greatly to Leonardo's taste, and his studies of anatomy inform the sureness of touch in the depiction of the skull that underlies the skin and the muscles of the jaw. The superb modelling of the head demonstrates Leonardo's skilful naturalism, which he later chose to abandon. The body in the portrait is unfinished.

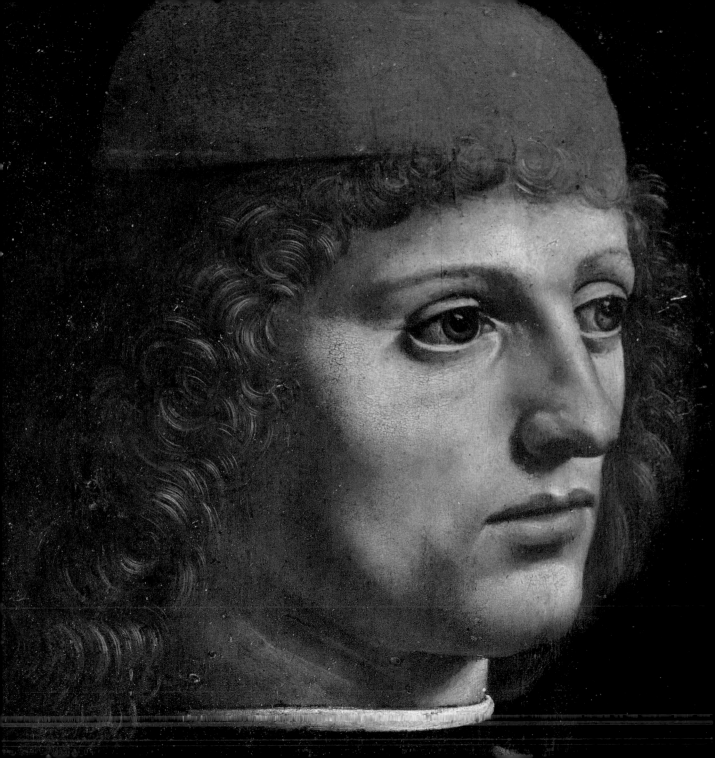

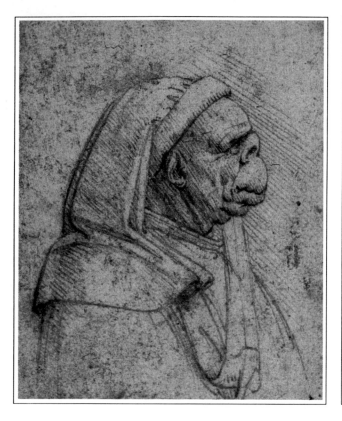
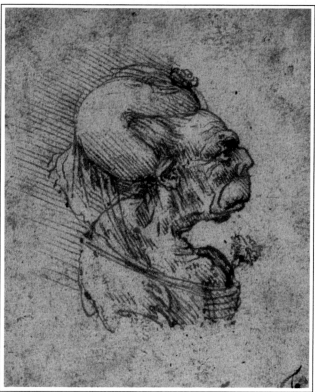

△ **Four caricatures** 1485-90

Drawing

ALWAYS REFERRED TO as caricatures, these were once the best known of Leonardo's works and were frequently reproduced as engravings. Modern taste tends to dismiss these drawings as grotesque, and in the same rather bad taste as the freak shows of the late 19th century. Clearly the features are exaggerated and, equally clearly, Leonardo found a great deal of pleasure in drawing them. It is known that he made a 'collection' of extraordinary-looking people but, given his passionate commitment to the close observation of nature, it is likely that what he drew was not really so different from what he saw. The late 20th-century eye tends to turn away from the ugly, misshapen or deformed – not so Leonardo's. A close

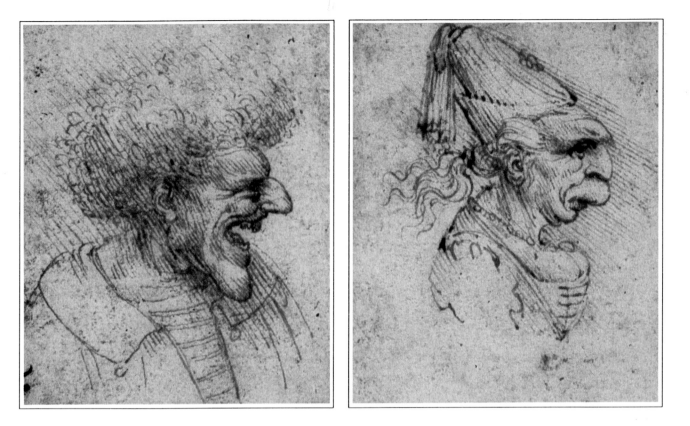

examination of his other
paintings reveals strong,
emphatic and even ugly faces
as part of his overall vision.
Critics might like to try
looking at the laughing face
(above left) without allowing a
good-natured smile to come
to their lips!

▷ Diagrams of Flying Machines 1486-90

THIS CONTRAPTION on the right is surely Leonardo's most bizarre flight of fancy – an ornithopter operated by four beating wings powered by hand-and-foot drums! Throughout this period, Leonardo was fascinated by the problems presented by flying machines and designed a variety of ornithopters (flapping-winged aircraft). In fact, he was working from the premise that birds are able to fly because they beat their wings downwards and backwards – an understandable mistake in the days before slow-motion photography. He was also wrong in believing that humans would have sufficient muscle power to emulate the flight of birds.

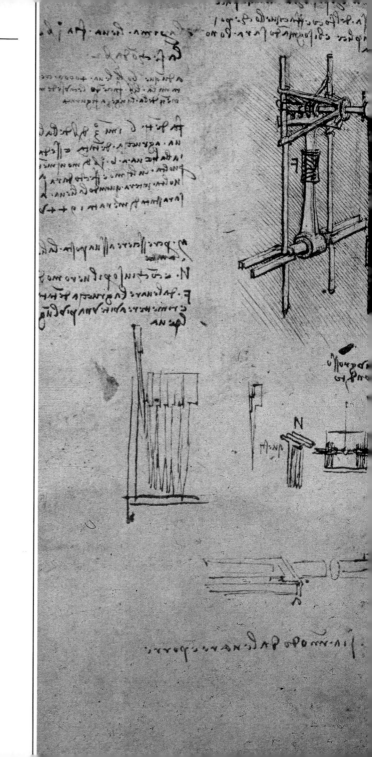

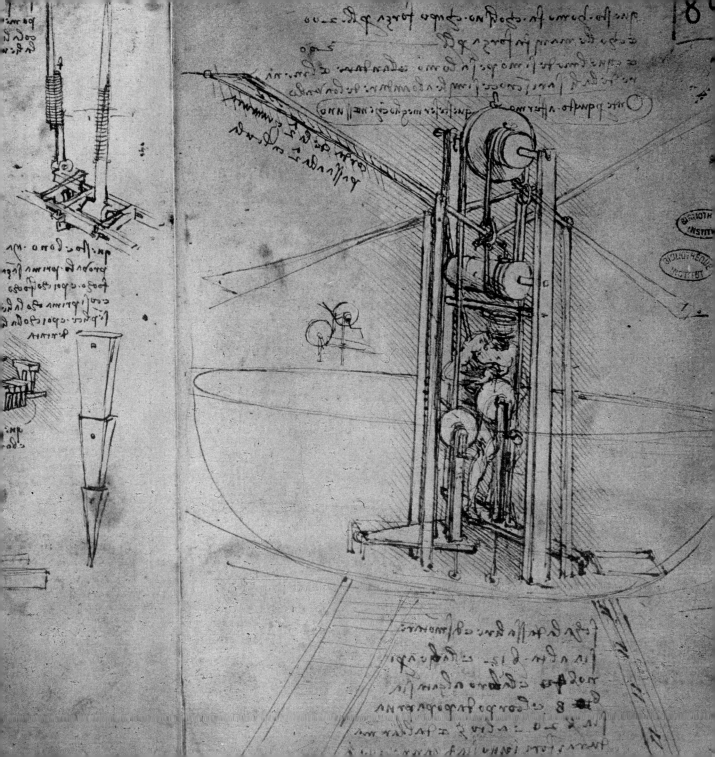

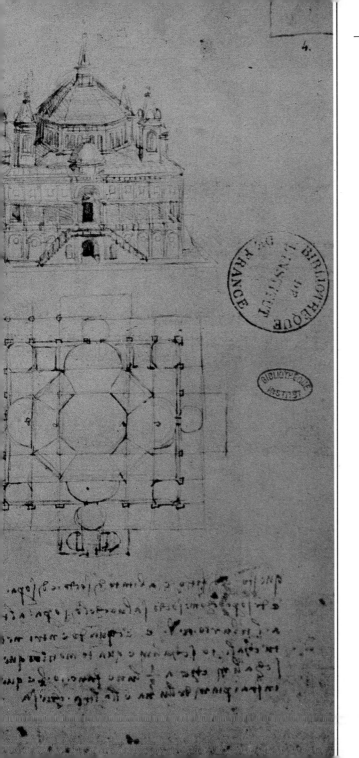

◁ **Plans for a Church** 1487-90

Pen-and-ink drawing

IN THE LATE 1480s, Leonardo focused his ever-inquiring and profoundly perceptive mind on architecture – a conjunction of art and science well suited to a man of such talent. This pen-and-ink design for a church, possibly suggested by Saint-Sepulcre in Milan, is based on a Greek cross. The building is square and surrounded by a portico. There are no records of Leonardo's ever being commissioned to design a church. It is most likely that his interest in ecclesiastical architecture was purely theoretical.

▷ **The 'Nutcracker' Man**
c 1490

Drawing

LEONARDO was fascinated by grotesque faces, and made many drawings which are now thought of as caricatures. The 'nutcracker man' was a recurring theme, often counterbalanced by the 'beautiful youth'. It has been suggested that they are an unconscious representation of the two opposing facets of Leonardo's own personality - the virile and the effeminate. There has been considerable debate about Leonardo's sexuality, but there is little evidence of any possible homosexuality, and it seems to have little relevance to his art. It has also been suggested that these two figures represent the Florentine and Milanese phases of Leonardo's life, but it is more likely that Leonardo simply enjoyed the contrast between the two and delighted in his own virtuosity.

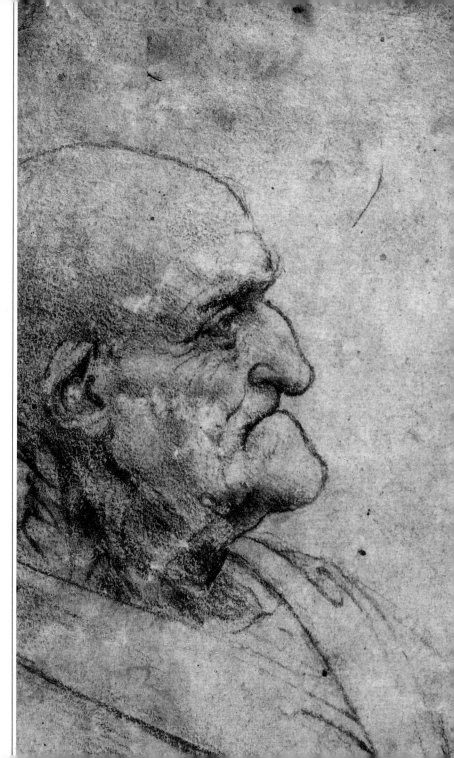

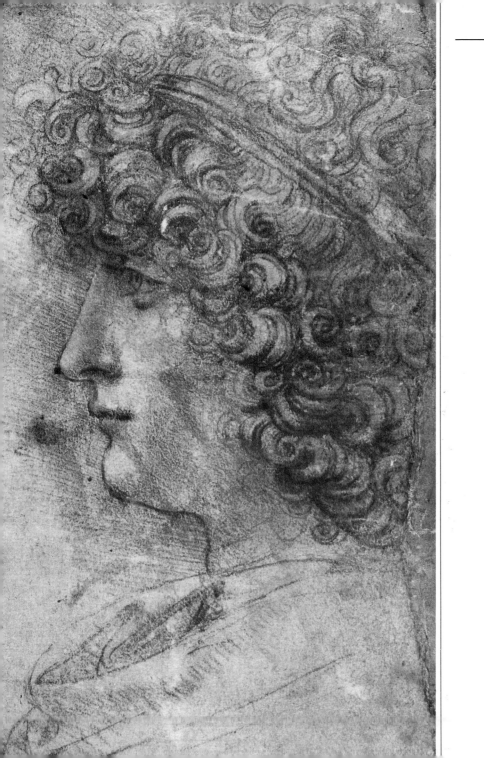

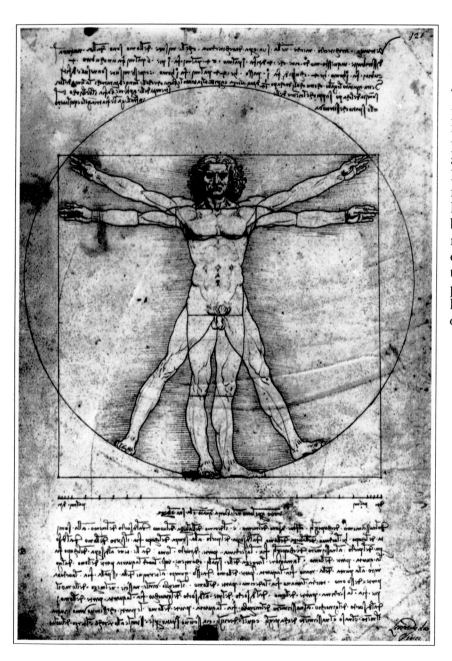

◁ **Vitruvian Man** c 1492

Drawing

THIS DRAWING of the proportions of the human figure is based on a famous passage by the Roman architect Vitruvius, in which he describes how the human form lying face upwards with hands and feet extended can be circumscribed, with the navel as the centre of the circle. He suggests further that the figure can also be enclosed precisely within a square. The head is calculated as being one-tenth of the total height.

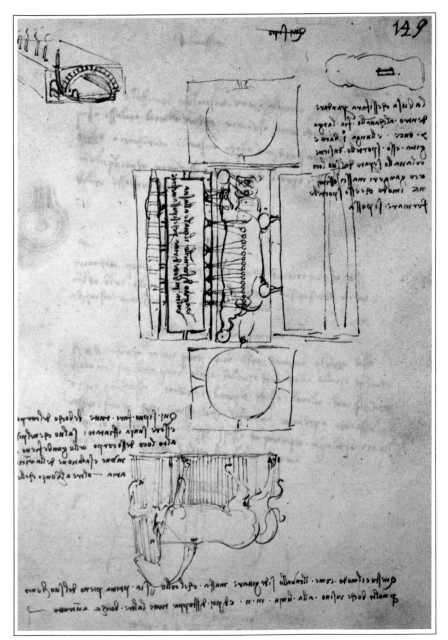

◁ **Sketch of Walking Horse**
1493

Pen-and-ink drawing

THIS PEN-AND-INK sketch is in the collection of Leonardo's notes and manuscripts known as the *Codex Madrid*. It is a study for casting a vast bronze monumental statue – the Sforza monument. As was often to be the case, Leonardo's impatience and desire to experiment outran the available technical expertise when he made his initial sketches. The horse was to be prancing – a typical Leonardo pose, but one which had never previously been executed as a monumental sculpture. Leonardo began work on the monument again in April 1490, choosing the more practical pose of a walking horse. He made detailed notes of the process to be used for casting the bronze, and constructed a full-scale clay model. The monument was due to be cast in December 1493, but Duke Lodovico disposed of the bronze to his father-in-law, Ercole d'Este. It is not known why. The clay model remained on public display in Milan, where it was much admired.

▷ Portrait of a Lady from the Court of Milan c 1495

THIS PORTRAIT was known, wrongly, as 'La Belle Ferronnière' through a simple administrative mix-up. In fact, the identity of the sitter is not known, although there has been speculation that she may have been Duke Lodovico's mistress at one time. More importantly, there has been debate about the attribution of the painting and suggestions have been made that it was the work of one of Leonardo's pupils. Certainly, compared with *The Lady with the Ermine*, for example, it lacks both vitality and interest. The pose is dull and the detail of most of the accessories is prosaic. However, the ribbon on the shoulder of the dress has a lively touch that is reminiscent of Leonardo and the painting of the face reveals an understanding of anatomy. Formal court portraits were, at that time, subject to certain standard traditional limitations. This work might simply represent a professional but uninspired commission.

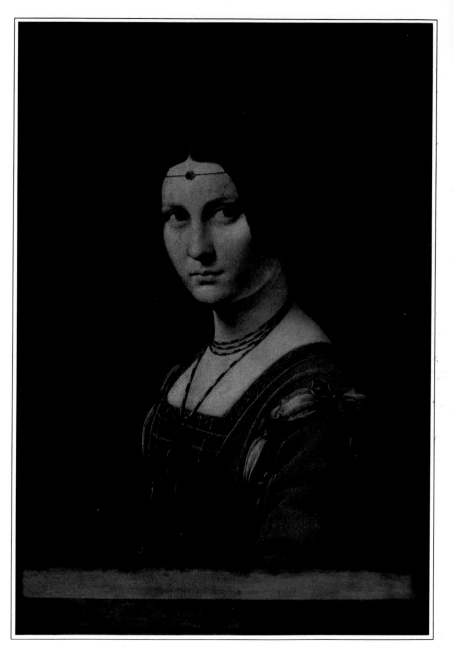

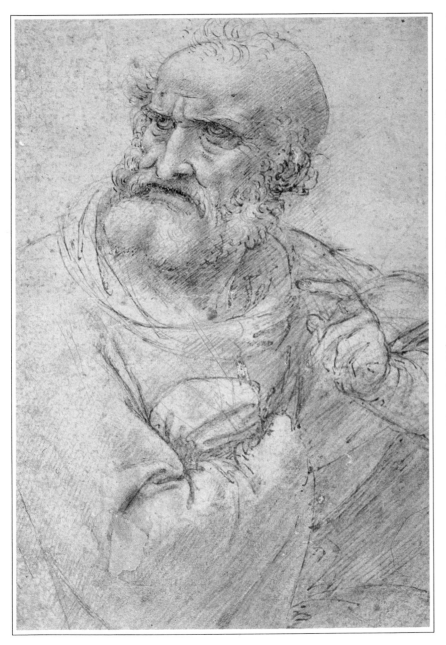

◁ **Study for an Apostle from The Last Supper** c 1495

Drawing

LEONARDO'S MANY existing drawings of *The Last Supper* make an interesting comparison with the final painting. Not only do they demonstrate Leonardo's characteristic revisions and development of the form and dynamics of the work, but they also refute those critics who have so savagely condemned the depiction of the Apostles and the awkwardness of their poses (notably St Peter, St Andrew, St James the Less and Judas). The gulf between the master's conception and skill and the lack of vision and sheer ineptitude of the many 18th- and 19th-century restorers defies description.

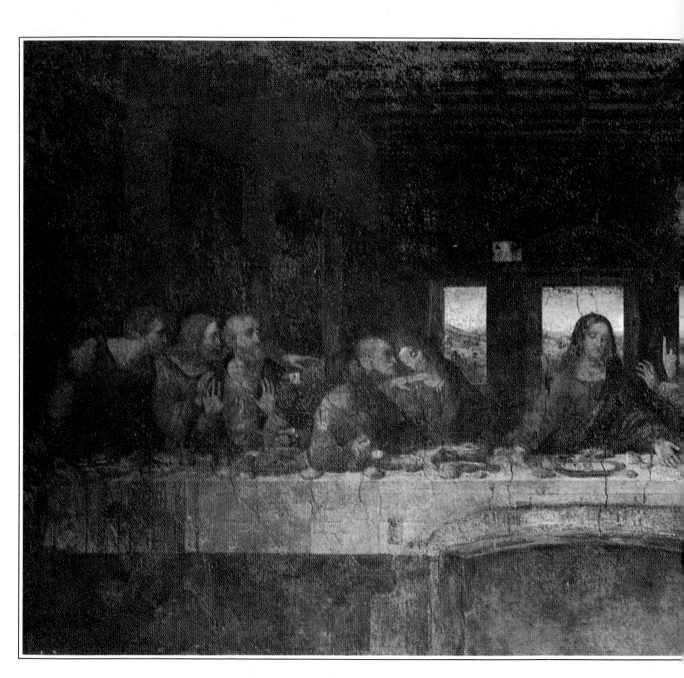

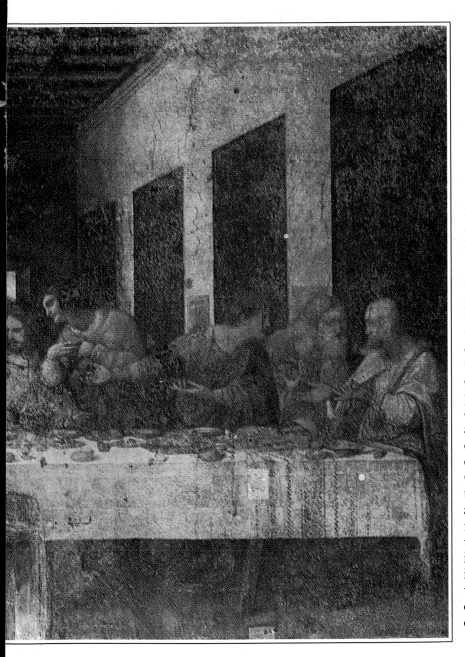

◁ **The Last Supper** 1497

COMMISSIONED BY Lodovico Sforza for the Convent of Dominican friars at Santa Maria delle Grazie in Milan. While partly painted in the traditional manner of a fresco – applying pigment mixed with egg yolk to wet plaster – the work also incorporates a medium of oil and varnish. Unfortunately, the painting began to disintegrate almost immediately, and a series of heavy-handed restorations followed. Recently, the painting has been cleaned, and the work of early restorers removed; but much of the original work is lost. But unlike contemporary paintings of the Last Supper, Leonardo's portrayal has unity. The dynamics of the composition and the simple setting lead the eye, as if by chance, to the central, unifying figure of Christ. The three Apostles on the left turned to the centre are balanced by two on the right who are turned away, but whose gestures lead the eye inwards. There is an awe-inspiring grandness to this work, which even the ravages of time have not been able to eradicate.

▷ **Giant Catapult** late 1490s

THE CROSSBOW, catapult,
trebuchet, ballista and sundry
other mechanical devices for
hurling rocks and heavy
objects at the enemy had been
known for many centuries.
Leonardo produced a number
of designs for refining such
weaponry. This is
fundamentally an enormous
crossbow: the carriage would
have been over 23 m (76 ft)
long, and the bow itself would
have measured about 24 m (80
ft) from tip to tip. It was a very
sophisticated design, planned
to give maximum stability,
much reduced road shock and
recoil and with great flexibility
in the arms. Leonardo
maintained that it could be
operated in silence. The
illustrations on the left are of
alternative firing mechanisms.

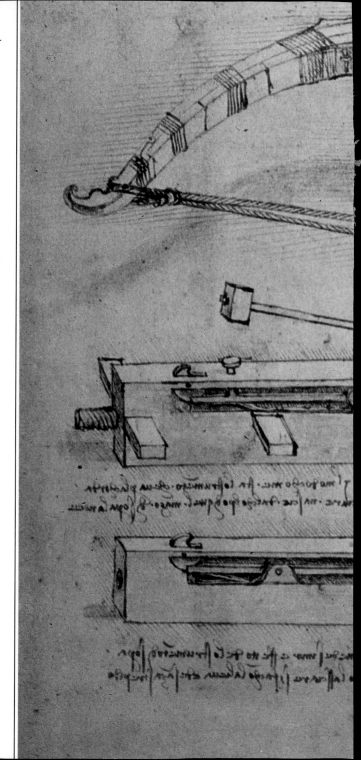

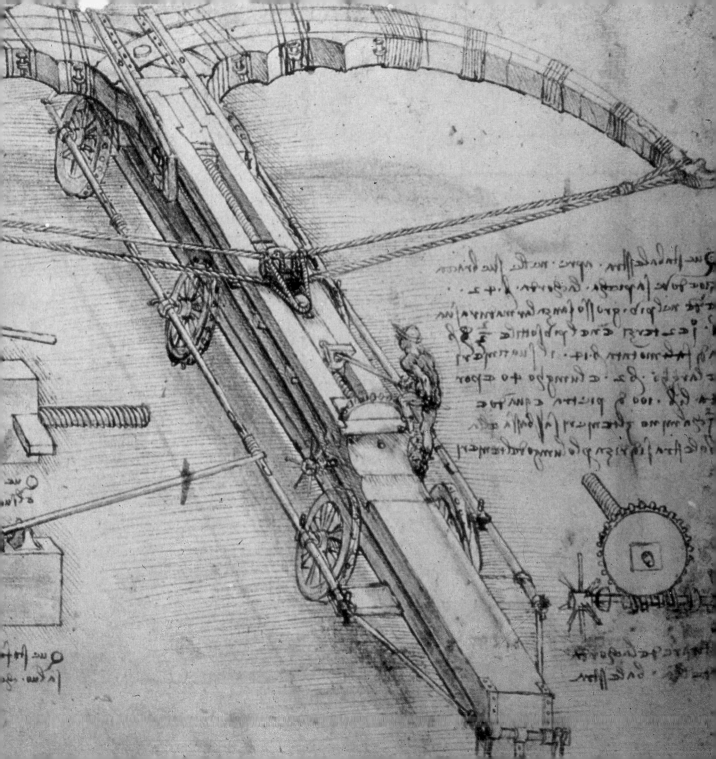

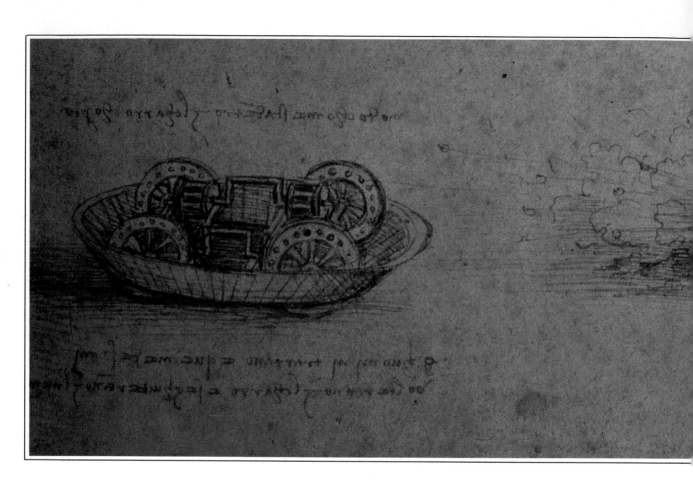

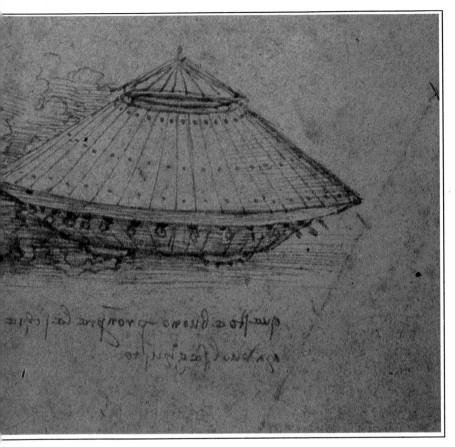

◁ **Drawing of the Shell of Tanks** c 1499

Drawing

TRULY A RENAISSANCE MAN, Leonardo probably never cared to limit himself with definitions. Nevertheless, he tended to regard himself primarily as an engineer, particularly a military engineer, during much of his time at the Sforza court in Milan. His interest in military matters was, no doubt, focused by the impending French invasion in the late 1490s. Leonardo did not invent the tank; there are both contemporary and earlier designs. His version, however, was exceptionally manoeuvrable. The drawing of the drive mechanism with the top removed (left) shows hand cranks – men being less likely to panic than horses in the heat of battle – attached to horizontal trundle wheels that were geared to four driving wheels. However, somewhat bizarrely, the cranks as shown in this drawing would have powered the front and back wheels in different directions. Possibly this was deliberate misinformation in case of espionage.

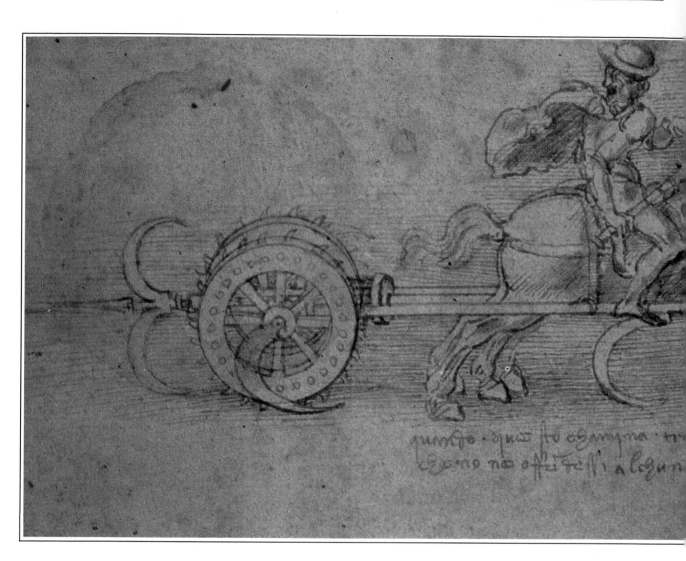

▷ **Scythed Car** c 1499

A CHARIOT WITH KNIVES or blades of some sort extending from the wheels was not a new idea. However, Leonardo set himself the task of creating an efficient, mechanized design. In this – one of several designs he created – two relatively small blades are fitted to the wheels of the car, while a huge screw turns four large scythe-like blades in front of the

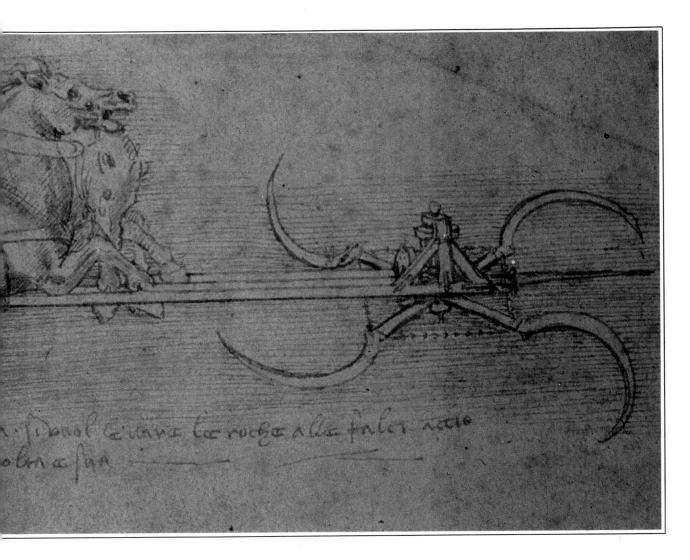

plainly terrified horses. A humane, animal-loving and, above all, intelligent man, Leonardo quickly recognized that the scythed car could inflict as much devastation on friends and allies as on potential enemies.

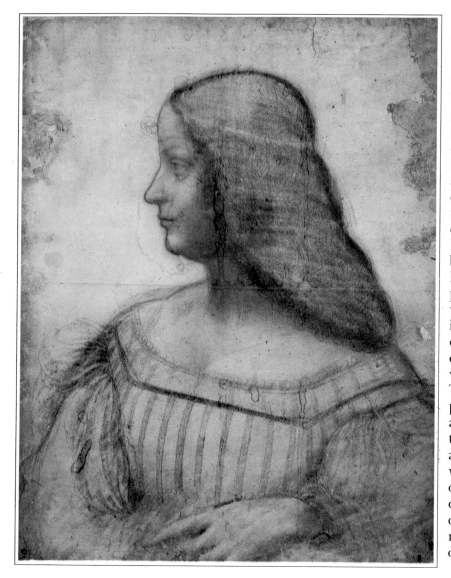

◁ **Portrait of Isabella d'Este**
c 1500

IT IS NOT KNOWN how long Leonardo stayed in Mantua, but it was long enough to draw a portrait of Isabella d'Este. Several copies exist - though only as a cartoon - and there has been some critical debate about which one (if any) is the original. This version, now in the Louvre, is usually thought of as being by Leonardo's own hand, but there has certainly been some reworking, and it has been pricked for the purposes of transfer. The pose, with the head in sharp profile, is unusual for Leonardo, but does offer an interesting counterpoint to the voluptuousness of the body. The arm seems to be positioned in a very odd way, and it is impossible to believe that a man as knowledgeable about anatomy as Leonardo would make such a mistake. In one of the other copies it is drawn in a far more convincing way, although the rest lacks Leonardo's sureness of line.

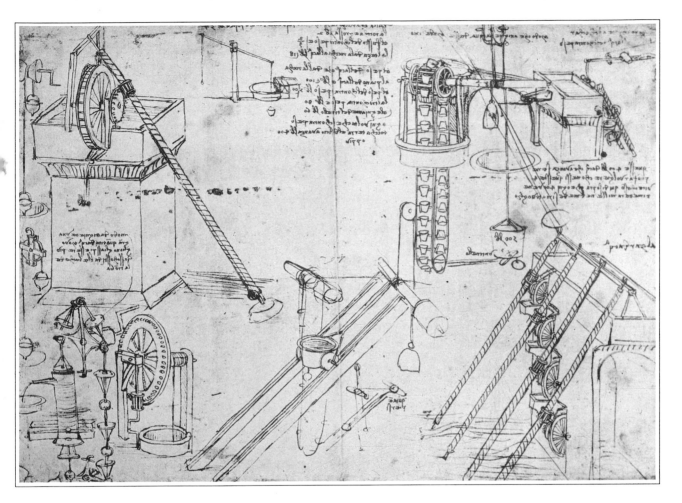

△ **Water Wheel with Cups** 1503

Drawing

THE *CODEX ATLANTICUS* , housed in the Biblioteca Ambrosiana, Milan, is the largest collection of Leonardo's notes and sketches in existence, but even this represents only a small proportion of his manuscripts and notebooks. Within this collection, many pages are devoted to pumps, watermills and various hydraulic devices. Leonardo was frustratingly restricted with many of his inventions, as the motive power which we take for granted nowadays – electricity, oil, gas and so on – was simply not available to him. However, he could allow his fecund imagination free rein when designing mechanical devices powered by water.

▷ Design for a Two-wheeled Hoist with a Caged Gear
date unknown

Drawing

ALSO FROM THE *CODEX ATLANTICUS*, this design shows an assembled view (left) and an exploded view (right) of a hoist, designed to transfer alternating motion to rotary motion in order to raise a weight. Two wheels, with pawls on their outside edges, are fixed on the shaft and operate in opposite directions. When the operating lever (right) is pushed one way, one of the wheels engages the ratchets of an outer ring, which in turn engages a gear on the final shaft. When the lever is pushed the other way, the second wheel engages its ratchet wheel, but the shaft turns in the same direction. Leonardo had a number of projects in mind, including a paddle-driven boat, for which he intended this mechanism. The superb clarity of the drawing – particularly the exploded view – is a joy to the eye, even if the mechanics of the process are of no interest.

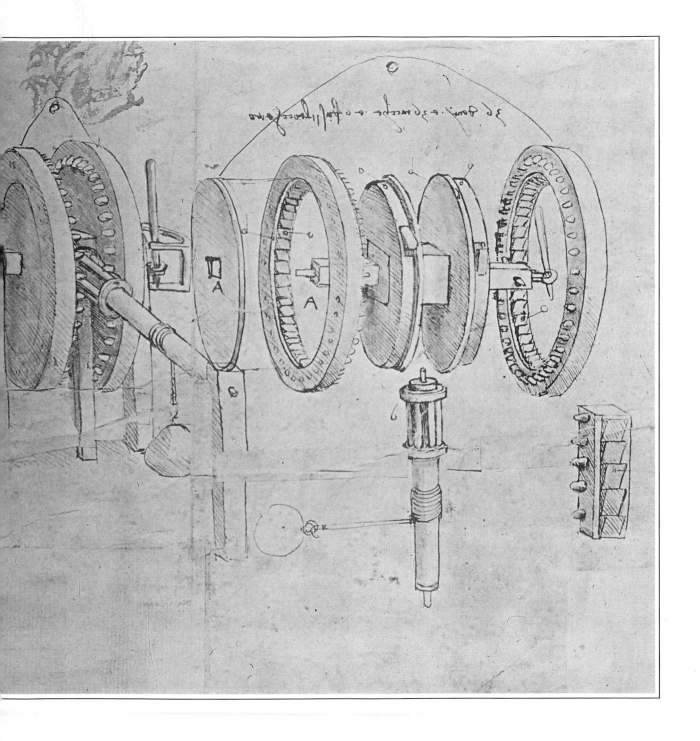

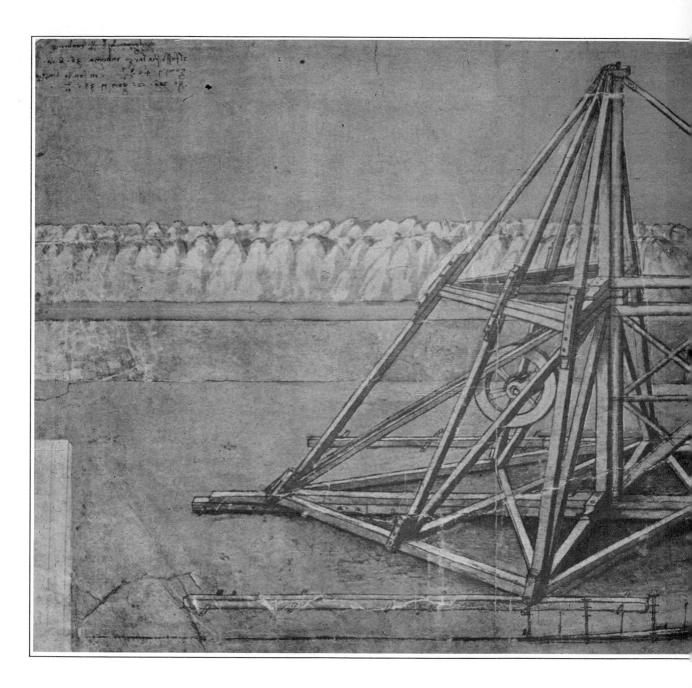

◁ **Design for an Excavating Machine** 1503

Drawing

ON HIS RETURN to Florence, Leonardo became involved in a number of engineering schemes, one of which was to divert the course of the River Arno via a series of canals. As he had in mind canals as wide as 18 m (60 ft) and as deep as 6 m (21 ft), some kind of powered digging machinery was a prerequisite. This machine (from the *Codex Atlanticus*) was mounted on three parallel rails. Two cranes, one above the other, were able to swing through 180° and the digging and soil removal process was powered by a treadmill.

▷ **Designs for Archimedes Screws and Water Pumps** 1503

Drawing

AGAIN FROM the *Codex Atlanticus*, these designs for various methods of raising water were probably prompted by Leonardo's involvement in various engineering schemes, including swamp drainage. He did not invent any of the devices; rather, he refined their technology.

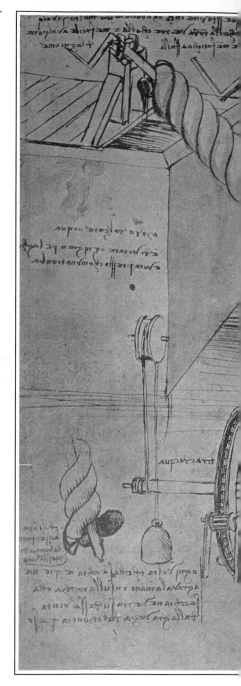

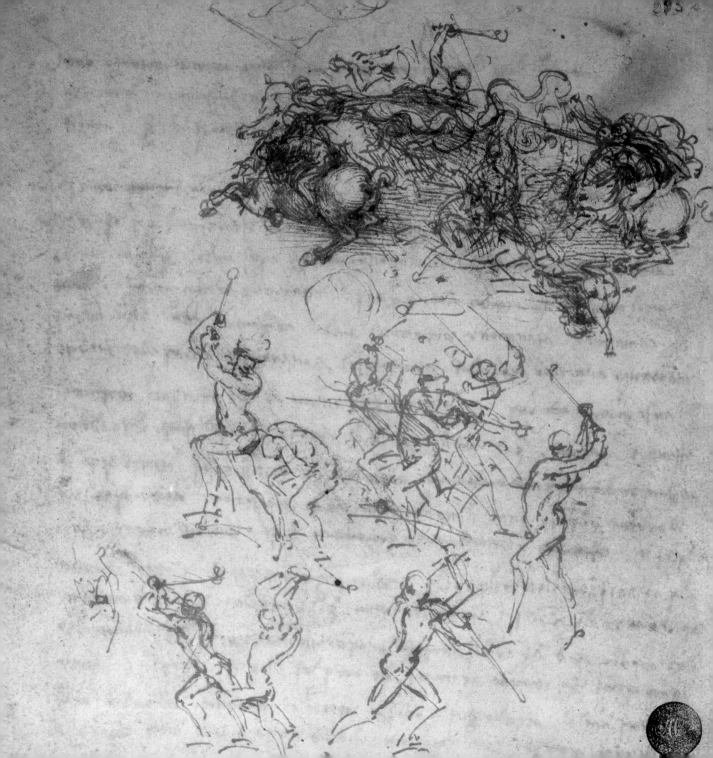

◁ **Studies for the Battle of Anghiari** 1504-5

See also pages 58-61

IN ABOUT 1503 Leonardo received what was probably his most important commission – to paint a large fresco in the Sala del Gran Consiglio, a state room in the Palazzo Vecchio. The victory of the Florentines over the Milanese at the battle of Anghiari was the subject chosen, one ideally suited to his talents. He had, in any case, wanted for some time to paint a battle. Work on the cartoon began in the autumn of 1503, but little progress was made on the fresco itself. When he did begin painting, in 1505, he experimented with a new technique, but its results were fairly disastrous. The work that had been completed lasted for a while, but was eventually overpainted when the Palazzo underwent major reconstruction in 1565. The cartoon is also lost, but preliminary pen-and-ink sketches still exist. Leonardo wrote at some length about the details he wanted to include and the emotions he wished to convey. He mentions dust, dirt and smoke, terror and the agony of death. Even the

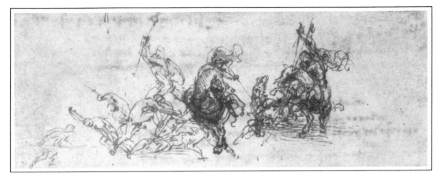

Detail pages 58-59

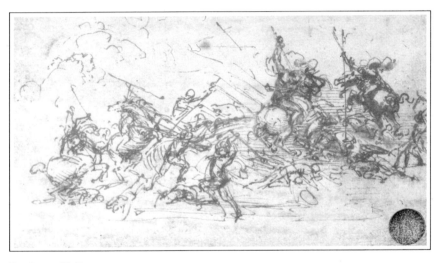

Detail pages 60-61

sketches vividly convey the confusion and fear of the battle. Leonardo drew many of his favourite twisting forms and overlapping figures to plan the composition. He worked on the shapes of individual warriors. For many years he had maintained that head and thorax should not face the same way, and soldiers in action provided him with great scope for conveying dramatic tension in this way. He also drew sketches of groups – horses and warriors, the living and the dying, and the victorious and the defeated.

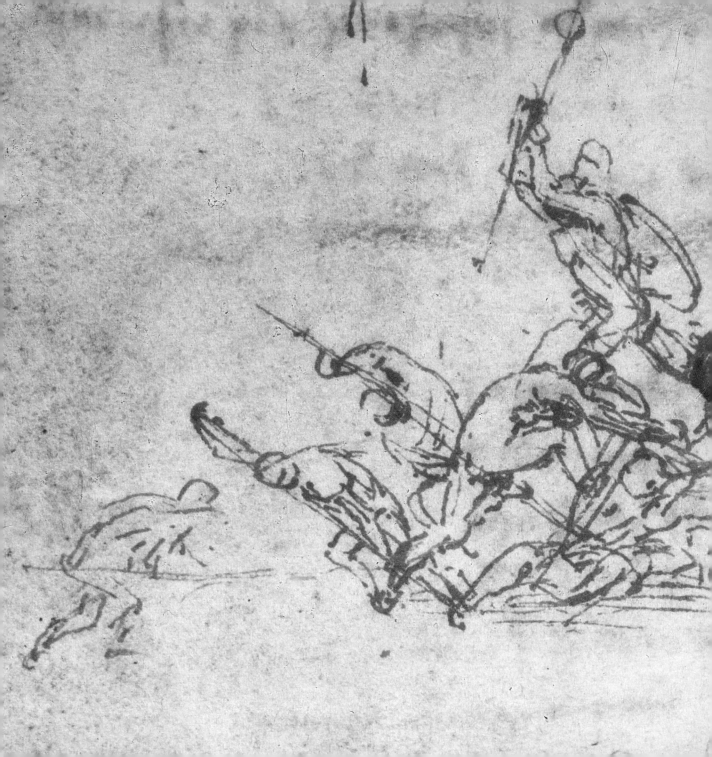

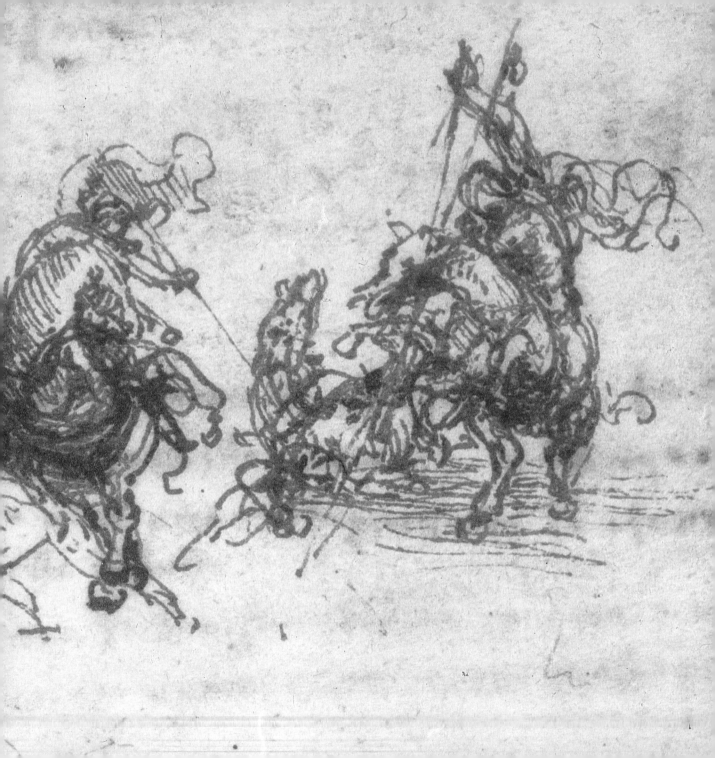

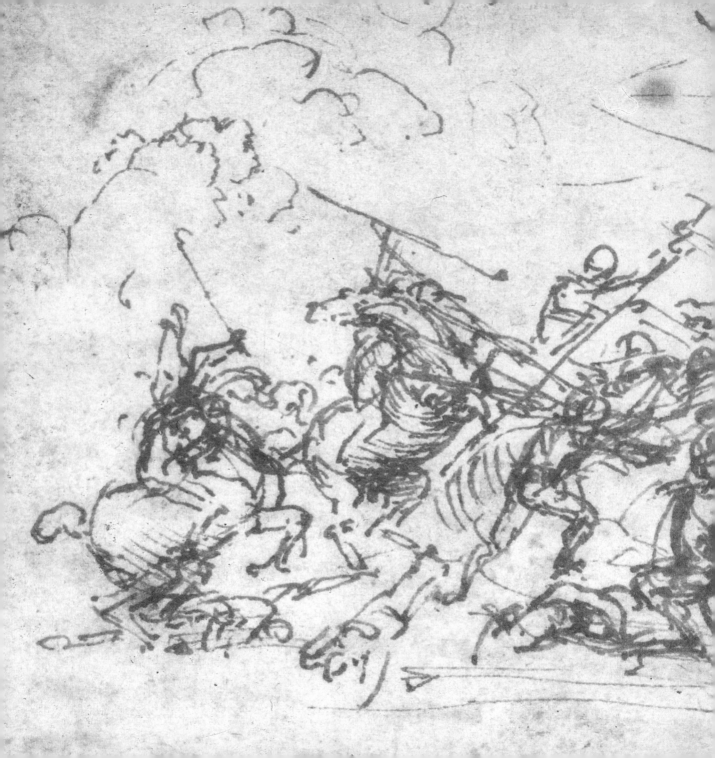

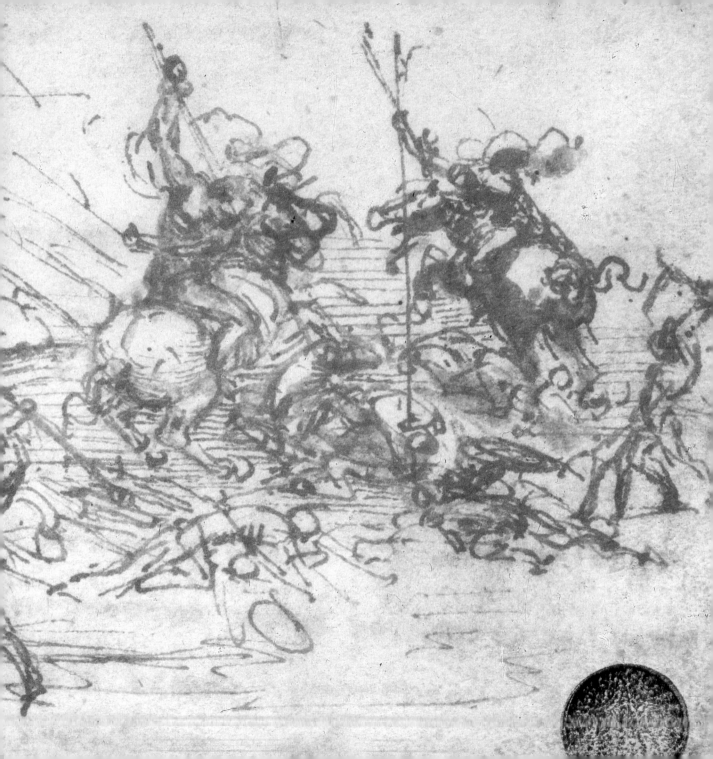

◁ **Cartoon of Virgin and Child with St Anne** c 1505

AS WITH MANY of Leonardo's works, dating is a difficult issue, not least because he approached the same subject on different occasions. There is evidence that he was at work on a Virgin and St Anne as early as 1501 – although this may well be the painting that currently hangs in the Louvre in Paris. It is more likely that this cartoon dates from after Leonardo's return to Florence. The importance of the young St John the Baptist, who was much revered in Florence, is evidence of a later date. Whatever the date, the shadowy, mysterious faces, the flowing draperies, the Virgin's tender expression and the young Christ blessing St John are combined in a powerful emotional intensity that makes this one of Leonardo's most loved works.

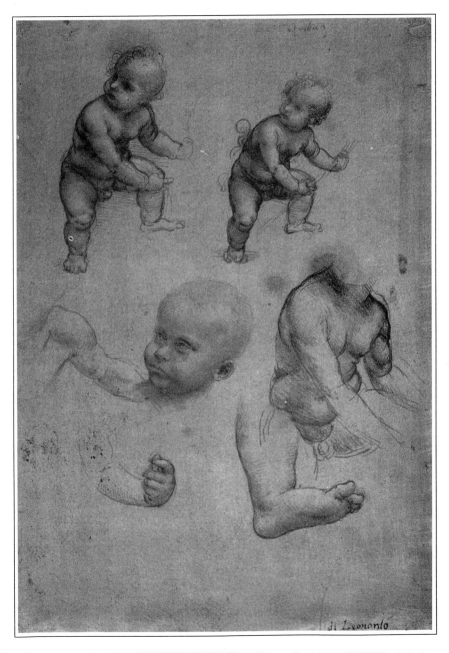

◁ **Study of a Child**
date unknown

Drawing

THESE CHARMING DRAWINGS of
a child were probably some
preliminary sketches for a
portrait or one element in a
larger composition. There is
something endearing about his
careful recording of the way
the toes of a baby's foot
separate and curl.

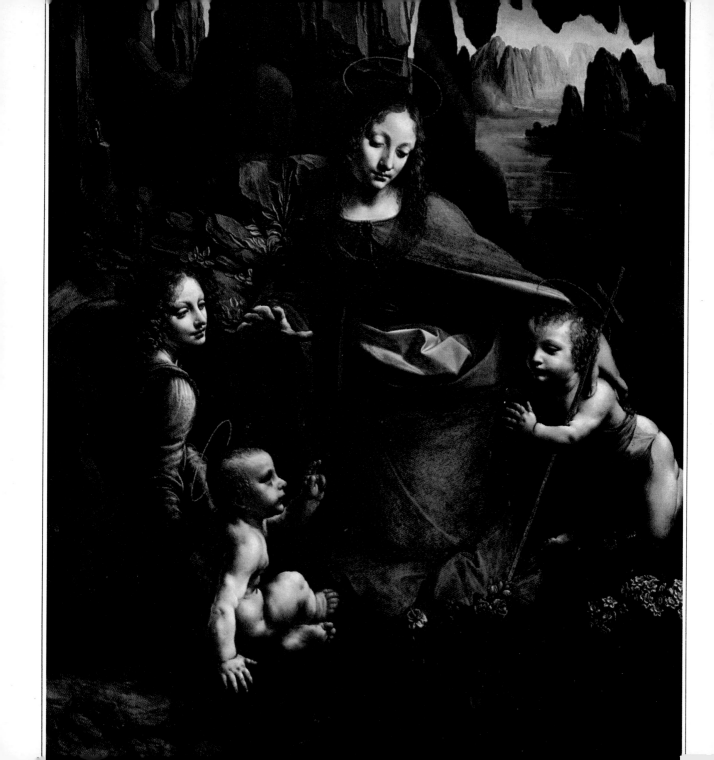

◁ **Virgin of the Rocks** 1506-8

THIS VERSION of the painting, now in the National Gallery, London, is probably the altarpiece commissioned in 1483, but much delayed. There are many subtle differences between this and the earlier painting. The quality of freshness has been lost, the faces have a more classical, less plastic beauty, the angel does not puzzle the onlooker, having ceased to gaze out of the painting and no longer pointing at St John. The infant Christ has gained a seriousness of intent and St John is somehow less adoring and more conventional. Perhaps the most major difference is the way that Leonardo has used the light. In the earlier painting, the figures are lit with diffused light, while the rest of the scene is in shadow. In this version, the chiaroscuro verges on the melodramatic, the light coming from a single source and focusing sharply on the figures' faces.

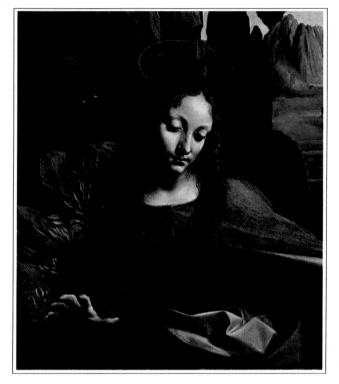

△ **Virgin of the Rocks** (detail) 1506-08

ART HISTORIANS disagree about how much of this painting was executed by Leonardo himself and about which of his pupils was responsible for the remaining work. The Virgin's face has acquired an ideological perfection at the expense of warmth and vitality. It has the delicacy of touch and moulding that are characteristic of Leonardo, but seems to lack his vision.

▷ **Mona Lisa** c1508

Oil

SO FAMILIAR is this painting and so often has 'La Giaconda's' famous smile been reproduced on everything from postcards to calendars that it is virtually impossible to look at the work with an unprejudiced eye. The safety precautions taken by the Louvre in Paris, where the painting hangs, make it not only the most assiduously protected picture in the world, but also one of the most difficult for the visitor to see clearly. Nevertheless, this portrait of a young Florentine wife continues to exercise a special magic. How much more exciting and innovative her lustrous beauty, luminous complexion and the relaxed formality of her pose must have seemed to the 16th-century viewer. The Mona Lisa's smile has been described as enigmatic, shy and exquisite. Other less complimentary critics have called it a crease in her face and that of the cat that has got the canary. Certainly, it is a smile derived from a worldly rather than spiritual source; she is a satisfied woman rather than a saint. Yet there still remains an element of something mysterious and elusive. In Leonardo's own writings about art and painting, he describes how the subtleties of character are most fully revealed by faces seen in evening light and bad weather. There is an underlying almost sombre quality to the light in both the portrait and the landscape which forms the background, which both reveals and conceals.

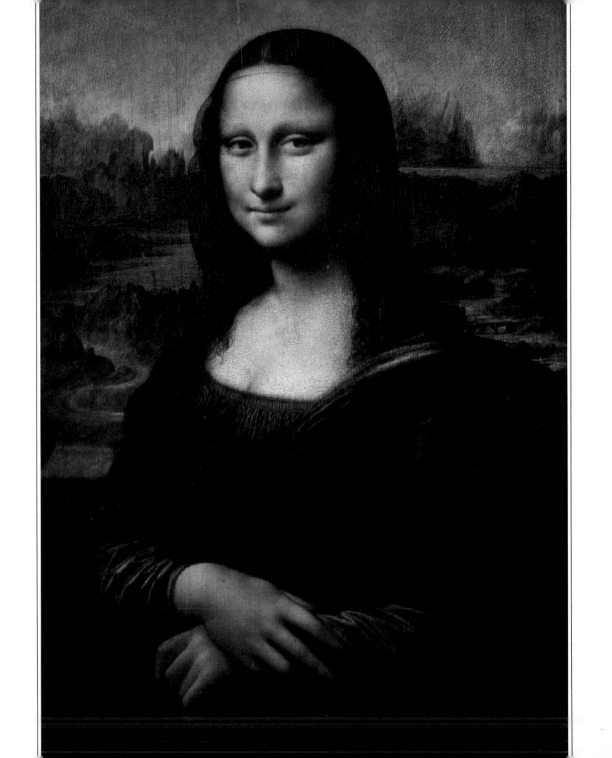

◁ **Notes on the Earth, Sun and Moon** c 1508

(see also page 70)

IT IS NO SURPRISE to learn that Leonardo included astronomy among the many subjects he investigated and on which he made detailed notes. These pages from his notebooks are concerned with the sizes of the earth and moon and their relationships with the sun, and the outer luminosity of the moon (*lumen cinerum*). Leonardo was left-handed, but this does not explain why he wrote in 'mirror writing'. It has been suggested that he was born right-handed, but injured his hand at an early age. He then began to write with his left hand, but working from the right side of the page and moving to the left, the natural action of a fairly young child in such a situation. Although this seems a likely explanation, there is little evidence to support it. It is a more reasonable suggestion, however, than the idea that he wrote in this way to keep his notes secret. A man of his intelligence would hardly delude himself that no one would think to hold his notebooks up to a mirror.

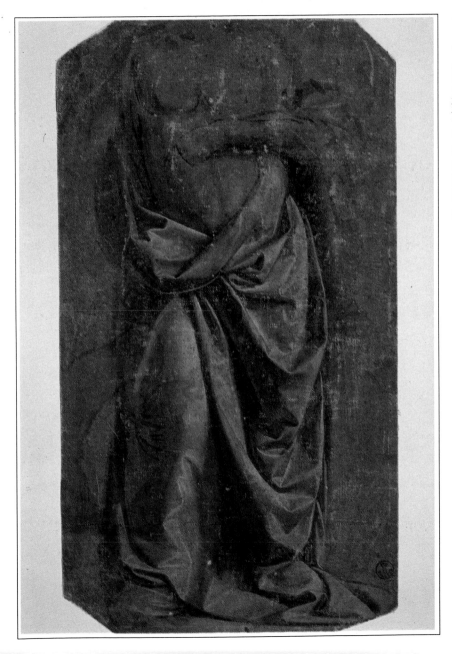

◁ **Draped Figure** c 1508

THIS DRAWING is one of many
studies made throughout
Leonardo's career of the ways
that the folds of draperies fall.
His figures always have a sense
of underlying solidity and
reality. Some of his
contemporaries seem rather to
have painted legless creatures
held upright only by the
stiffness of their robes.

Detail

▷ **Virgin and Child with St Anne** 1508-10

THIS WAS A THEME that Leonardo explored on a number of occasions. The infant Jesus reaches forward to embrace the lamb, a symbol of how the adult Christ would embrace the Passion. The two women look towards him with tender expressions, as the Virgin reaches to support but not restrain her son. He returns her gaze with an assuredness, understanding and wisdom beyond his human years. This was a painting that fascinated Sigmund Freud, the pioneer of psychoanalysis. He interpreted the painting as an unconscious representation of Leonardo's two 'mothers': his natural mother and his step-mother. The Virgin and St Anne – both 'beloved figures' - are depicted close in age, their physical forms intermingled and sharing a mysterious remoteness. Fanciful or not, there is no doubt that this is a painting of great power and beauty, but the onlooker is gently and firmly excluded from the emotional force that informs it.

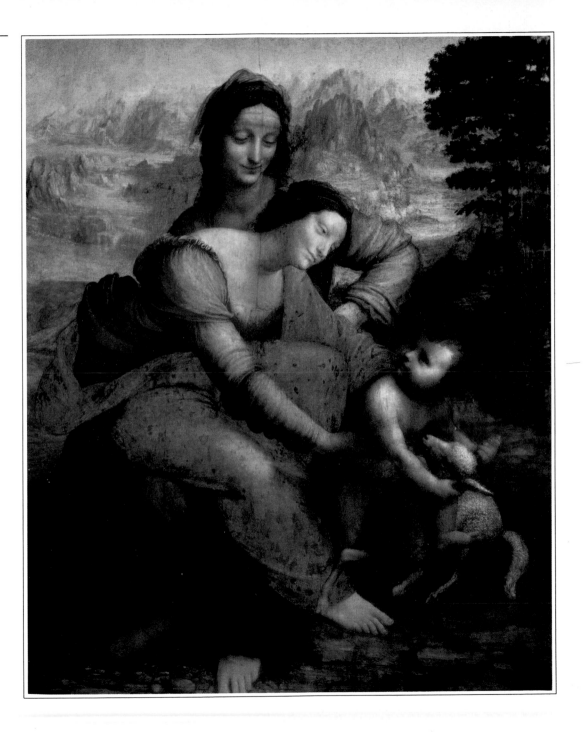

▷ **Drawing of the Proportions of the Head and Eye**
(date unknown)

LEONARDO REINFORCED his observations about the human body by studying anatomy. While he was in Florence, he was allowed to perform dissections at the hospital of Santa Maria Nuova. As always, he made notes and drawings. Although he had a good knowledge of what happens beneath the skin, as well as a thorough understanding of the relationships between different parts of the body, as demonstrated in these notes o the measurements and angles of the facial features, his paintings never seemed wooden or academic. His knowledge informs his work rather than dictating its structure.

▷ **Self-portrait** c 1512

Red chalk drawing

THIS DRAWING is the only authentic portrait of Leonardo. He has chosen to present himself as a figure of wisdom and authority at a great age, although in fact he would have been in his early 60s at the time. A private man all his life, he reveals less of himself than we might wish. There is a sense of his humanity and keen intelligence, but the drawing has an almost archetypal feel to it, so that it could be virtually any man in old age.

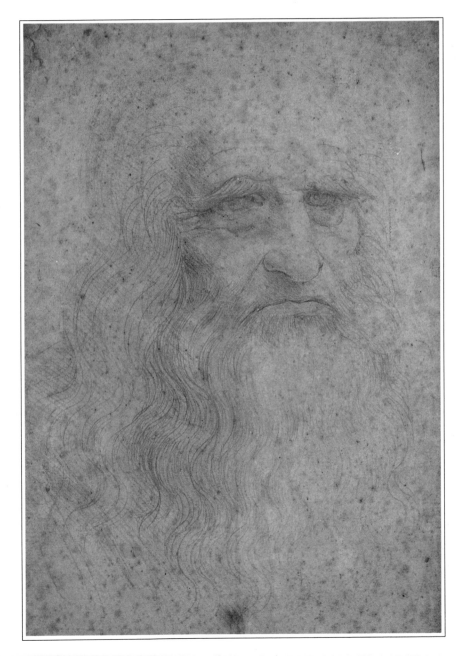

▷ Anatomical Drawing c1513

THROUGHOUT MUCH OF his working life, Leonardo kept notebooks in which he made anatomical drawings and notes. Not content with simply absorbing the knowledge of anatomy and physiology already published by Hippocrates, Galen and Avicenna, he conducted his own studies and dissections. His biographer, Vasari, records that he met Marc Antonio dalla Torre in about 1510 and this great anatomist helped Leonardo in his researches. The notebooks are dated, but it is not always apparent when the work was completed. This drawing of hearts and blood vessels was intended for a textbook that Leonardo planned to write.

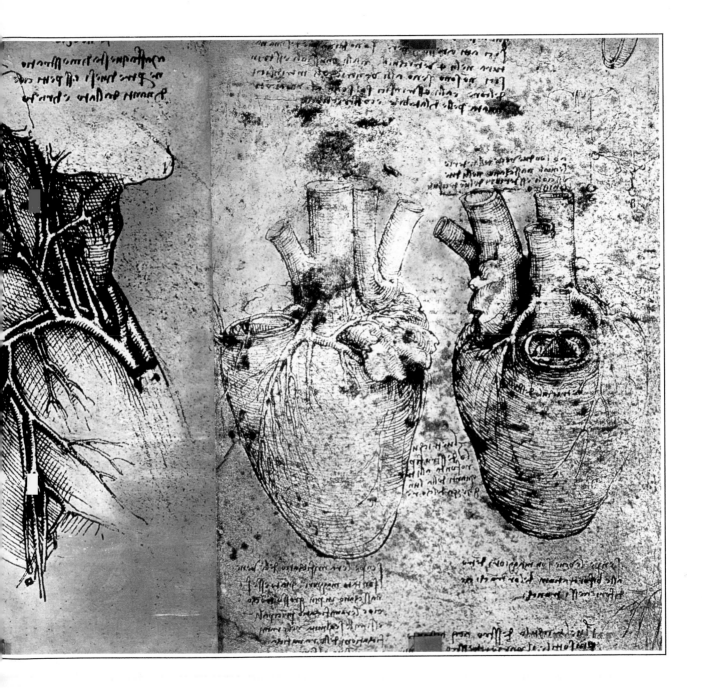

▷ St John the Baptist 1513-16

LEONARDO'S LAST surviving painting is, perhaps, his most controversial. There has been widespread debate about the significance of the Saint's pointing hand, and his enigmatic smile has provoked as much discussion as that of the *Mona Lisa*. While the torso has a certain solidity and strength, the face and expression have a delicacy and mysterious gentleness that seem to contradict the character St John – the uncompromising, abstemious preacher in the desert – as described in the Bible. Yet Leonardo was one of the most literary painters of the Renaissance, and it is impossible to believe that he conceived this figure and pose without reason. It may be that he chose to portray St John in the moment following the baptism of Christ, when the Holy Spirit in the shape of a dove descended on Jesus.

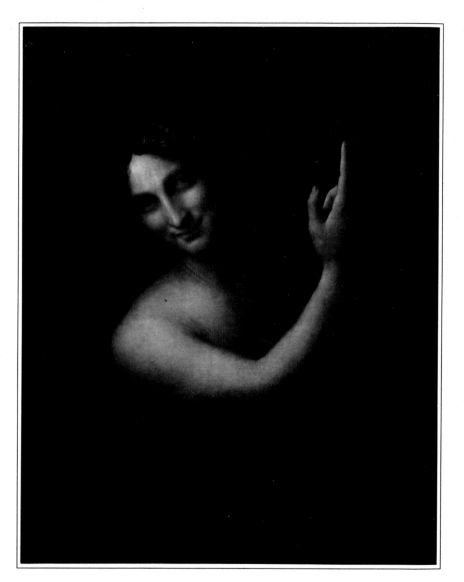